LADY IN A BOAT

ACKNOWLEDGEMENTS

The following poems have appeared before in the publications indicated:

'On Visiting Cyprus – (1) Dreams', and 'Sea' in Stephanos Stephanides and Susan Bassnett (eds), *Beyond the Floating Islands,* COTEPRA, (University of Bologna, 2002); 'The Word – In the Beginning' 1 & 2, in Peter Hulme and William Sherman (eds), *'The Tempest' and its Travels* (Reaktion Books, 2000); 'Hoping', in Karen McCarthy (ed.), *Bittersweet* (The Women's Press, 1998).

LADY IN A BOAT

MERLE COLLINS

PEEPAL TREE

First published in Great Britain in 2003, reprinted 2010
Peepal Tree Press Ltd
17 King's Avenue
Leeds LS6 1QS

ISBN 978184523850

Completed with the help of a
Creative and Performing Arts (CAPA) award
from the University of Maryland

Supported by
ARTS COUNCIL
ENGLAND

Riddle

Lady in a boat
With a red petticoat

Answer

Nutmeg

For my father

For Merissa

CONTENTS

CANDLE

Put a candle on the step.
Open the boucan door
let the rats run out.

Air out the place and give the sun a chance.
Let light reach those shadows in the corner.
Put a candle on the step.

QUALITY TIME

QUALITY TIME
for my father

They say what he has is malignant
but they promise more good years.
Now, they say, it's quality time,

so he's smiling. Words like
quality and malignant,
you could probe and unwrap them

but he's batting, protecting his wicket.
The game's going on, and he's
out in the field again

with cocoa and cashew, guava and gospo,
mango and mortelle, nutmeg and nettle,
soursop and Seville orange; he's

spending some quality time.
They say,
We got it all, but it's malignant,

and he wonders.
They say, *Go easy*,
but his batting is steady

and he's smiling.
But soon, he's brooding,
could feel strength going down, could see

suckers pushing out,
draining the cocoa tree dry,
could feel how the vines curling

and stifling. Could see how
bush growing high and it
choking the crop.

He notice how
most mornings sun blaze
boastful over mountain,

shine bright for a time, then just
sink down dying over the sea.
They say,

We tell you, it's quality time,
and he leans on his bat and he wonders.
The crowd is watching and waiting,

his batting is weaker, light getting bad,
he can't face the bowling,
sun heading down to the sea.

Bowler runs in, crowd leaning forward,
ball hit timber, wicket done scatter and
suddenly so, sun get swallowed by sea.

I REMEMBER THAT ROOM

I remember that room
the clothes press, mahogany, the heavy drawers,
the door that had to be coaxed or crushed closed,
my mother speaking her longing for a proper, modern closet
and me thinking for the first time, a silent sacrilege,
that in some things I was more my father's child.

I remember that room
the door leading to the old bathroom
the trunk known always as Daddy's trunk
the place where you kept your suits from nineteen nought,
your ties, your private papers,
the passport you used
perhaps for the first time in twenty years
when what you had was named terminal
and we chased doctors, looking for more good years.

I remember that room
the old windows you loved,
the cords so worn, windows wouldn't stay up
whether you begged or cursed them.
I remember when the bed was where the press is now
how you leaned there, how you lifted our little sister
when only you were strong enough to carry her
how she watched your face as if you

were her world. I remember that room
but mostly I remember
one of those days when you had started counting time.
You, standing there facing the press,
the trunk, open and rusting, on your right,
the door to the old bathroom just behind you
and me, asking, *Tell me something about*
the place where you lived when you were growing up

I remember how your lips trembled
as you almost whispered
What do you want to know?
Like, what do you want to know, before I go?
You were looking past me and I dared not turn around
I saw your eyes fall before death's stare
and I didn't know how to take back the question.

NOTES ON BLUE

Notes on blue paper
Nutmeg bonus, so much
Vegetables sold, so much

Cocoa, so much
Salary, so little
For the year

86 written in neat print
after the paper's 19 at the top
For 1986, the total

Eighteen thousand
and fourteen dollars
and forty seven cents

You didn't know it then
but you had ten more years
of anxious scribbling.

Notes on blue paper
loan payment
the name of a bank

and a scribbled
one thousand dollars.
I hope that was a payment

for the year. Blank blue
tells the rest of the story
and there is part of it, too

in the memory
of a voice lamenting,
This man working every day and

never, ever have a penny,
of a voice asking,
What is it that you doing with money?

I inherit the scribbling of the accused
who, knowing the failings
he couldn't afford to have

made a monument of silence
that now stands, solid,
.in his defence.

IN THE SHADOW OF THE MOUNTAIN

When she see it she say,
This is it?
This really is the place

where you bring me to spend my days?
He watch the mountain,
he look back at her face

and is like he either stupid or he
playing dotish, because he ask,
What you find?

And is a kind of wonder in her voice
when she answer,
This darkness?

This bush? This rutty road? This
damn desolation? The laugh that he laugh
wasn't joyful, wasn't bitter.

He look up at the green bush
covering the mountain
and he thinking,

Land rich. He watch the yellow
cocoa pods peeping out and
the green ones in and between

and he thinking, *Time to do a picking soon.*
He consider the rutty road and he summarize,
Well, mountain land, what to do?

He think of the question about bush, about
rutty road, about
damn desolation,

he turn to her and he ask,
You find so?
She?

Is long time she know that if
tongue must be decent, is not
every word it must answer.

Mean time, night time descending,
six o'clock is twilight already.
The stone steps like slabs,

the drab grey board house,
the shingles:
he see antique, she see

dirty and dingy.
And what is that up there in the awning?
Bats hanging down?

Well, yes.
What a place!
And looking around, she say,

Is now I understand a lesson
in my reading book a long time ago.
In a bush, in a bush,

in a bush where beasts can talk.
The man who write that
must be was living here.

And she look far away and proclaim,
At least I think that is the sea
over there in the distance.

He?
He turn his back on the sea.
He look up at the house, he

watch the green mountain,
and he pointing. *They call it Mount Gozo.*
Some say it mean old bones,

some say delight and some again say,
joy. Watching the dark mountain, she mumble,
Some people have a funny idea of delight.

Not able to help himself,
he clear his throat and he chuckle,
Some might well say is delight.

CONVERSATION

Afterwards, I knew the script had been written,
scene set, props prepared,
long before the pull and tug of life dragged us to that day.

We could not have planned the raindrops huge as grapefruits
thumping on the open galvanize.
We could not have wished into place
wind in the trees,
rain pushing mangoes from their branches,
some ripe and ready for the fall,
some green and seeping acrid milk.
We could not have planned the sun,
soaked and sheltering,
but winking still,
in playful hide and seek with constant rain.

It must have been all this,
rain, wind, mangoes,
dark day, insistent sun, that made me say,
In his lifetime, he achieved a lot.
She answered,
Death works in mysterious ways its wonders to perform.
I heard,
There are those who must invent easy tributes to the dead.
In a tone offered like a hangman's rope, she asked me,
Like what? What did he achieve?

The rage in her voice was softened only
by the rumbling rain, as she said,
He worked all his life,
left not a penny in the bank,
had not one grand thing to show
that he could say he paid for,
what little God put in his hand,
he squander it on women and nonsense.
So what, she asked me, her tone now a quiet question,
What did he achieve?

She spoke against the sound of the rain,
pushing at the branches of the mango trees he had planted,
of the wind,
circling and shaking the grapefruit tree he had pruned,
shuffling the leaves of nutmeg trees he had loved and left.
A Seville Sweet bounced against the galvanize of the shed,
fell with a splash into the copper below.
That's when he would have said,
I must empty that copper tomorrow
before mosquitoes start to settle.

But all of that
was drowned by the thought that he'd squandered himself.
It closed her eyes and
whipped memories around her face like blinding streaks of rain.
It puffed her cheeks and
made her blow hard from the rage rattling her thoughts.

She had told me more of his story than he ever could, or would,
had told me of his childhood home
in a dirt dry and broken place called *nigger yard*,
had told me of some of his
cringing, bow-head *nigger yard* times,
how he never knew
a father set sail for more solitary, productive climes
before his son was even born,
had told me
how in his youth this fatherless son walked every day
from *nigger yard* to plantation house,
cleaned the yard, fed fat chickens, picked up eggs,
shadowed one or two for the quiet delight of kitchen staff.

And those tales explained
where he learnt to sing
Man is lonely by birth
in that fine baritone voice
told me
where he learnt to laugh as if
life had given him some secret story to chuckle over.
And though he never really seemed to know his story
enough to tell about it,
I had heard enough.

And now, telling more,
there was the rain, cuddled in clouds
riding over mountains he had loved to stand and watch.
There was the wind, rattling the guava tree he had planted,
dragging at the cocoa knife he had shaped for picking,
and there the sun, shoving its shine through all that rain
just to promise that it would soon come out again.

It must have been all this,
the cuddling clouds, the familiar mountain,
the wind's stories, the insistent sun,
that made me say,
If achievement is dollars, perhaps he didn't achieve much,
and here she pulled my words and shaped them
to speak her own conclusion,
But if it's children, I guess you could say he did.
Dropped them all over the place, she said, as she watched the rain.

So I dared to tug the collective pain, to shape sentences for him.
Those who were his children had a father who didn't run away.
Each one knew him, whether he had a lot to give or not,
whether the knowing tied you up in knots or not.
And her eyes declared me Judas
as she whispered, wondering,
Is that an achievement?
And without my speaking an answer, she found one that
made her grieve, *Woe, woe is me, when that is his achievement.*

And as we listened to that other raging wind,
she stilled and murmured,
I guess he did walk a good walk
when you consider how far he came.
But whatever the story, she said,
he sure had plenty help along the way.

SE MWE, NUTMEG
(IS ME, NUTMEG)

DREAM MOURNING

For seven months, and seven
days, they trudged every night
across the yard. Tell me you

didn't see the long white gown
for death, for mourning, for bit-
ter endings, for more dread be-

ginnings. Seven months, seven lingering
days, thirteenth March to nineteenth October,
they drift down from mountain

into dreams floating in the
drugged sleep of dithering days.
They come with the shape of things

to remind you. Pickaxe, hoe,
cocoa knife, fork, rod, cutlass,
cane stalk, basket, straw hat, boots,

banana on *kata*, spade.
How else to tell you? They dance
in copper, polish cocoa,

circle grinding stone to re-
mind you. Tell me you didn't see
lines trudging, two-stepping, dark

night after prophetic night.
Perhaps you didn't want to
see the knotted cloths, boxes,

bundles, quick over shoulder
glances, didn't wake to wonder
what happening and why. Say

you didn't hear a whisper
whistle across your dreams, didn't
see people weep, frightened and

drifting, boats on muddy wa-
ter weaving and waiting. Tell
me you didn't see shadows

crouched by the water, didn't
jump from sleep wondering what
old hurt haunting you again

and why. Seven months, seven days
of mourning, revelation
opening itself to you

and waiting. But dream revel-
ation is smoke, not your kind
of knowing. Then come rage, come

splash of blood, come pounding feet
come horror of the past be-
come future crucifixion

again. And now, they've taken
the dead dreamers back to mount-
ain to feed the fountain of

dreams again. What this mean? That
man more human than he know?
That woman need to let her

misgivings show? That young dream-
ers get drunk on the newness
of knowledge and turn from the

wisdom of old?

MORNING GLORY

People say since that year be-
gin, the spirit world was rest-
less. Dogs howl till moon stop to

watch. They say a smell of new
blood was sour in the wind. Wood
spirits roam, people trembling

in darkness. Big tree get weak
and come down crashing. Bush gram
say dead walk all through the night.

They say the land upset, sea
bazoodee and every fruit,
every flower in distress.

Pawpaw leaf green and healthy
all of a sudden diseased
and dead. They say nutmeg bear

without mace that year. How I
buy these things, so I sell them.
I make not a cent profit.

They say it was like the root
of that year rot in the ground.
Callaloo shrivel up, the

drain full of worms, morning glo-
ry waking wrong time of the
day, opening itself in

the evening when the sun sink-
ing into the sea. And people
dream of a lady in a boat,

dressed in red petticoat, a-
drift and weeping. And all won-
dering, what this mean? What change

the balance of things? Some who
could see say, *The ancestors*
creep into our sleep, cry in

our dreams and leave us feeling
toodie in daylight. And when
you look back at that year, study

things the ancestors knew, watch
how morning glory droop-
ing today, you wonder which

way? Which direction to turn
for some warmth from a rising
sun?

OCTOBER, ALL OVER

Batten down door, cover up
window, buy matches and can-
dle, I tell you, acquire

masanto. Caribbean
hurricane season and wind,
raging, could just wind down on

rooftop, grab it, lift it up,
swing it high, fling it free, move
it with a rhythm and a

rhyme there from time. *June, too soon;*
July, stand by; August, look
out, you must; September, re-

member; October, all o-
ver. But that hurricane sea-
son was cool as cucumber.

Sky blue, no warning from ra-
dio, days sticky like wet co-
coa, sweating, turning slow,

even the warning from time
wasn't sounding urgent. *June,*
too soon; July, stand by; Au-

gust, look out, you must; Septem-
ber, remember; October,
all over. But sudden so

one day in October ra-
dio shouting bout rumours
of wind. Some say, cho, some say,

chupes, is October, all over
already, man. Ain't got to
batten no door, worry bout

candle. Hurricane season
gone through if you really stu-
dy the regular rhyme. *June,*

too soon; July, stand by;
August, look out, you must;
September, remember; Oc-

tober, all over. You know
hurricane develop in
secret? Not a whisper in

breeze till wind with its rumour
shake roof in October. June
was soon, July, still soon, Au-

gust, soon, soon. September, well,
starting to remember. Oc-
tober, wind was rage, was ri-

ot, raise people and fling them
dekatché them who dead, who
dying, who behind bars. So

October, all over, oui.
You know nuff rooftop gone? Who
disappear, disappear and

folks watching the sky begging
for a sign, for some relief
from this sudden destroying.

And same October so, all
over in truth. You ever
see that? Look how you could lis-

ten to a rhythm all the
days of your life and never
get the form and the turn

and the meaning of the thing
that it saying. June, too soon
July. Stand by. August, look

out, you must. September, re-
member October. All over.

PEARLS

When the marines stopped the car
and ordered them out, he laughed.
When they were told to open

the boot so it could be searched,
he laughed. One marine said they
were looking for Cubans, and

he laughed. The marines lifted
the mats off the floor of the
car, and he laughed. They finished

the search, touched their hats, waved them
on through Pearls, and he laughed. He
said, *This is my country and*

a foreign soldier just searched
me, and he laughed so hard that
he shook. *This experience is*

precious, he said; *you can't buy*
it. He grinned and added, *But*
we paid cash for it. Then he

said, *The worst thing is, I guess*
we invited this. Chicken
don't look up and squawk when it

know chicken hawk is around.
He laughed again and said, *It's*
the most natural thing to

resist an invader, don't
you think? He considered and
mused, **Even**, and he paused, ***even***

if you don't support the ones
they say they come to get. He
said, *The point is, they're inside*

of your house and they're acting
like it's theirs. He laughed. *They were*
looking for Cubans; that's not

why they came. He concluded,
I guess resisting would be
illegal. And he laughed. Said,

Once, resisting slavery
was illegal. And the worst
thing is, we bring ourselves

to this. He said, *You're always*
the one with answers. What you
think we should do? She glanced at

him and was silent. She watched
the road as she drove and he
laughed like he would never stop.

OCTOBER BLUES

So I have the October
blues. Mid October comes and
in my head a helicop-

ter hovers. A roving re-
connaissance rumbles. In a
picture postcard paradise

bumbling bombs blast explosions
on a fumbling, fearful fort.
It's nearly mid October

and I feel those October
blues again. In my head, bombs
with night vision seek cave mouths,

angle to slip inside. Aunt
Myra's Jacob is there. He's
no revolution shouter

but he wants the things he's told
revolutions bring. Food, health,
prosperity, of course, and

education. I have the
October blues because in
my head bombs explode across

the mouth of a cave and Mark,
my cousin, took cover there
when the last attack began.

Military facility,
that fort. He's there because they
carried him there. He's ashamed

because he has no belief
in his country's leaders. Still,
he feels a traitor because

he wants to leave. *Big dogs bark*,
he mutters, *then the pups run
out to die*. I have these im-

ported October blues, these
Caribbean sea blues. In my
head is a still blue picture

of Rose, loading guns. She's there
because, support this leader-
ship or not, nation is home.

She wants no kind, invading
father figure to preach love
of human kind. I have these

October blues because I
see again my friend lying
in a drain. A pig nudges

at his body. A man with
dreams, my friend, not red dreams but
dreams wet with the sea-blue hope

of a bright Caribbean dawn-
ing. I have October blues
because I see again the dour,

determined face of Dan, who
shoulders his gun and mutters
that he blames the Chief for this

awful mess. *Not firm enough*,
he mumbles of the murdered
Chief. I get those blues because

everywhere there's some vengeful
masochistic mauling. I'm
sure some sister, somewhere, has

September blues, some brother,
some place, croons November blues.
I know there are hot weather

blues and rainy season blues,
spring blues and whiter winter
blues. Someone some place has a

year crammed full of blues blowing
days. I'm not alone with these
recurring Caribbean blues.

ROLL CALL

I see you everywhere. For
all these years you've haunted my
journey. You swim with me and

pull me back, clutching through white
waves, at drifting straws. All these
years, and still I feel we need

a mourning at the empty
grave, need to chant a *chandi-*
nèl kléwé, need a serious

wake to sing the names, and mourn
the loss of innocence that
brought us to this day. Ghost prints

of a blooding still not cleaned
haunt every step we aim to
take. The wounded land, the kick-

ing volcano under the
sea, will the dead to walk tall
in memory again, till

the hurt, buried deep, breaks through
the scab to burn raw and heal
in salty air. Simple quest-

ions. How many were lost? Who
lost an eye, a hand, a leg?
Which mother wept a silent,

mournful dirge because her child
died for a discredited
cause? Are those a daughter's hands

digging for a father's broken bo-
dy? Is that a son's silent
sigh of sorrow that sours each

striving day? Were those mourned lost
the first day or the next? When
the party was over and

guns appeared, or was it when
the eagle swooped low to
terrify and calm the tremb-

ling prey? The sea kicks, rumbles,
fumes its own tributes to those
who could see horizon where

others saw just endless surg-
ing seascape. Time has seen much
done in the name of love.

Shouldn't we want to know, even
if we pronounced them wrong, which
dreamers gave life for love of country?

Bodies broken, scattered, bruised.
Can you call their names? Who are
their parents? What are the names

you are ashamed to call? Such
a shame to feel such shame of
struggle for belief in self.

How to pretend not to know
of the raw wound in a na-
tion divided?

Whose is vengeance? Whose is guilt?
And what have we learned? That de-
fense, attack, silent shielding,

all of this is love, that the
world crucifies itself for
love, that love can torture, love

can kill, love can praise itself,
lie low and restrain itself.
Love can be so sure it's right

that it can rise again to
destroy yet again for love.
Love can pray in any language

before it kills. Love is a
terrible, terrifying thing.

SUN PHILOSOPHER

Eighty years on this earth, eighty
I have to say I'm satisfied with the show
won't be unhappy to leave when the bugle blow.

Every morning, I look out of this kitchen window
watching sun rise over the mountain
and when I see it up and ready to go again

I smile and say, *Sun, today, today, we beating the rain.*
Sometimes a cloud in the way and sun stand back
but cloud have it place and you know sun on track.

And that is how I feel sometimes; a cloud come over
but me and sun, we moving up the track together.
Sometimes I ask, *Sun, how the world going?*

It know shadow not afraid to darken the day
and I giving thanks for things that show me the way
know each kick push you on, didn't keep you back.

I sweat on that hill up there, in the land
I sew, cook, teach, take night and make day
leave the land, take boat, try to make me way

go to Port-of-Spain, Oranjestaad, Brooklyn, London
see my brothers sail to Maracaibo, Cuba, Colon —
one set of poor people that travel well, my people.

Sun, you rise over all the places my man folk travel
Florida, Mississippi, Miami; and I, making miracle
with little money because turn-hand is life lesson.

But situation now is something turn-hand can't handle
politicians have the world in a total swizzle
it worry me before but now it worrying me more

I wondering if eighty is age young people could score
what with cancer more than it ever had cancer before
what with Aids, what with war, what with weapon

man make for destruction of masses.
My husband used to say, read newspaper, listen to views
and later, when television come, watch the news.

But who want to hear always wars and rumours of wars?
My husband, God rest his soul, like to talk war
declare himself veteran of World War II.

Never mind he didn't reach too far before war done.
But when war come to me, my blood pressure rise
same time with the planes that patrolling the skies.

I listen to the children to hear what ideas go around
and I frighten for these youth out there on the ground.
I say to my children, stay away from rock stone dance

where eggshell stand not the slightest chance.
Well, Sun, time for me to start to dance
to my own tune this rising day, to pull up weeds

get a move on, plant some seeds
pick two guava, trim the bouganvillea
look around my yard and try to put some order.

But my world so wide, Sun, I need every prayer.
Three of my six children in America, one in Canada
two in England, scatter so wide, prayers can't done.

You know how it is. You do your work, you hear, Sun
I do mine. If God spare, I will watch you this evening
when you going down over the sea, like you sinking.

SE MWE, NUTMEG

I don't want to boast but mine is a fancy face in the town.
True I living in bush but I love mi red and mi basic brown.
And when you see I have mi yellow coat over mi red petticoat
se mwè mèm, Nutmeg, that is really queen of my country's court.

Cocoa like to think he is king when picking time begin,
just because a ripe yellow take over the leafy green.
Even banana think he tough and can't get hurt,
till they chop him down and he face in the dirt.

But don't get me wrong. I ain't wish them nothing bad.
Is me and is them. All round the hill, things kinda hard.
But let we face facts, that is all I really ask.
Let we take a inventory and add up mi marks.

For flying high on mi country flag, I taking ten out of ten.
For producing one third of world wants, ten out of ten
For spicing up rum punch, don't give me less than ten.
For flying high over the U.N. in New York, is a even ten.

Look at me. With mi yellow coat, mi bright red petticoat
se mwè mèm, Nutmeg, that is really queen of my country's court.

But we talking through this thing so bring your thoughts to the ring.
Settle down. We taking we time. Is me and is you, discussing this thing.
You have me flying so high, I so exotic, so wholesome, so nice.
Me is pappyshow in all tourist basket with the country spice.

Sometimes when I up there with the stars over the U.N. in New York
I does really want to come down, just to have a say in the talk.
The breeze bringing mutters, how young people leaving the land
and I peep over by Brooklyn, and wonder who still home on the sand.

I check inside Pace University. I see nutmeg grower children there.
They paying U.S. dollars, oui, nearly three of ours is one in there.
I know their parents' work with me on the land is a labour of love,
so I just turn my face to the wind, flashing support from the flagpole above.

What to do? I playing my part.
You see mi yellow coat? Check out the red petticoat.
Se mwè mèm, Nutmeg, that is queen of my country's court.

But let me tell you something about a few exotic days in the land.
Mammie, Daddy, Auntie, cousin and son, all lending a hand.
Thirty, forty hours, picking nutmeg, collecting nutmeg under tree,
pushing back leaf on ground to find me, Nutmeg, taking a spree.

Then overseas market say, *Fifty East Caribbean dollars, total pay.*
Black hen chicken, eh. Have a sense of humour and you well on your way.
So with these old time crop, young people can't want to stay.
One hour work in construction bringing plenty more pay.

People coming back from England, they building house with pound
One multiplying by four, sometimes nearly five, so Nutmeg staying on
 the ground.
Those coming from U.S. building hotel and house with the dollar
 from there.
Even their meanness more generous than generosity here.

So let me enjoy mi spice and mi niceness, you hear.
Watch mi yellow coat. You see mi red petticoat?
Se mwè mèm, Nutmeg, that is really queen of this country's court.

So in spite of mi exotic flying, mi future looking bleak.
My country small and my bargain power weak.
I watch the red white and blue up there with a few
and wonder what to do that would put me in the queue.

I watch stars with the stripes; I wonder if stripes does complain.
I just can't understand how the world organize the disorder so plain.
Still, I surviving the years. Put nutmeg oil on your joints and they
 never creak.
I cool. I cool like me this nutmeg is really cucumber, though I wanting
 to speak.

With my yellow coat, my bright red petticoat
Se mwè mèm, Nutmeg, that is queen of my country's court.

BALLAD OF MACE AND NUTMEG

A children's chant

Mace and nutmeg went to ride
In the back of a little old car
Mace said to nutmeg, *Where are we going?*
Do you think, my friend, it is far?
Nutmeg peeped out through a hole in the bag
And peered at red mace in the dark
I can't say, my dear, I'm really not sure
But I wish I weren't in this sack.

The car went on along a bumpy road
Nutmeg groaned and shifted and rolled
Mace, she said, *I still really don't know*
But I think my dear we'll be sold.
Mace crumpled down, looked lonely and pale
Then nutmeg started to sing
Mace, she said, *you're my petticoat red*
So don't be afraid of a thing

When we were born we lived on a tree
Were safe in a yellow boat
When the boat opened out, I was pretty and brown
And loved my red petticoat
Then the older we got the less we could grip
We fell from our safe yellow home
Now time has moved on, our growing will change
We'll remember our land as we roam

SHAME BUSH

All these years, people say, and still Grenadians not talking
Nearly twenty years and look is silence that reigning
They remember good days, and that's the constant lament
Can't forget the promise of that jewel of a movement
They remember mango nectar, guava nectar, mango juice
They remember the airport, everybody plan, only one could produce
All over the land, the talk was popular education
They remember schools in agriculture, the striving of a nation
So is not as you might think that people memory short
They grieving for the hopes we destroy, for the things we distort

But they don't talk because
touch shame bush
see how it curl inside itself
Watch shame bush
see how it close to defend itself
Study shame bush, let me see you do that reading
you will understand the silence people keeping

People remember bad times when they see a smiling party face
They keep remembering how party bring them down in disgrace
Bush gram say is not just the killing on the fort that galling
The announcement on radio, the crossfire story still haunting
And the silence don't mean people bitterness gone to rest
So might as well talk it out, help get it off the chest
People wonder if is true who excel get emulate
Who act, who stand firm, who didn't hesitate
And is not as you might think that people living for the lie
Bush gram still saying plenty to make the nation cry

And touch shame bush
see how it curl inside itself
Watch shame bush
see how it close to defend itself
Study shame bush, if you really do that reading
you will understand the silence everybody keeping

Look is twenty years and the nation still hurting
People playing a waiting game, they just not talking
Is hard if men suffering on the hill for things they didn't do
People not relenting because they have their memories too
Dust don't disappear when you sweep it behind bed
People stay quiet but all the questions in their head
Is true time could heal and bad times could change people mind
But we have to figure how to talk, leave the hurt behind
And if you bright and reading plenty book
You must realize how the silence must look

Because touch shame bush
see how it curl inside itself
Watch shame bush
see how it close to defend itself
Study shame bush, if you really do that reading
you will understand the silence people keeping

Sometimes I wonder if I really know the problem that we got
Enough people feel responsible, pull the trigger or not
But people concern is not who feel they in a bind
They more worried about the quality of the ruling kind
And I ain't worried because I think communism bad
I live capitalism, I know how that could be hard
I feel people worried about if a leader is the compassionate kind
You have to wonder about a ruler with an arrogant mind

And touch shame bush
see how it curl inside itself
Watch shame bush
see how it close to defend itself
Study shame bush, let me see you do that reading
you will understand the silence that reigning

All the quiet that surround us is the silence of pain
Is the quiet of caution; this destruction mustn't happen again
Is the quiet of those who criticize a leader that popular
Never thinking that would mean a sentence of murder
Is the silence of those who confused when invasion reach
Their own act like the devil so they welcome marines to the beach
If you looking for serious change to happen again
Read every kind of book, but learn the local refrain

Touch shame bush
see how it curl inside itself
Watch shame bush
see how it close to defend itself
Study shame bush, let we see you do that reading
you will understand the silence people keeping

52

COUNTER

He was in prison,
his brother called to say.
I learned he was considered counter

to the ideas of the revolution,
that he planned with a counter group.
He was in prison.

I used to be his teacher, I explained.
He's young, I said, foolish perhaps, not dangerous.
I learned he was considered counter.

I saw his calm face in the second row
And knew I was too close to that distress.
He was in prison.

Months later, he was released, no charge.
I saw his listening face in the second row.
I learned he was considered counter.
Artist, teacher, vacillator, I found no counter answer.

HAUNTED
(for Stephen)

His name came to me by fax
shot dead in ambush
no one seems to know
for sure
if it was political
everyone knows it was murder
I once heard a friend call him
haunted
this student of mine
meaning
he teased
he joked
he laughed
he loved life
he was loved
he glowed
death didn't seem to walk with him
but he was haunted
twenty years later
his memory haunts
haunted
hunted
rested

MUSIC

perhaps you are
lucky

when you are in
tune

with the music that's
playing

not so those

who want a different
song

I D OPEN THE GATE

For one

If I could open the gate
and let you out, I would, but
that's not clarity. It's the

sentimentality you
once warned against. You see,
I trust in your spirit, that

unsettling word. If I could,
I would hold open the gate
to set you free. But there are

mothers, sisters, brothers, child-
ren, who would grieve to see you
walk. And I know there must be

others not guilty. And even
for less innocent ones who
have had time to think, I would

ask, whose is vengeance? And, knowing
the question would hurt many,
whose is guilt? And how to

speak of double loss? Haven't
grown a lot, you'd probably
say, because if I could pull

open the gate to set you
free, sentimental as I
ever was, I would do it.

A LETTER AND A NOTE

A LETTER

Day One
I hadn't planned to write you in this the twentieth year,
but the ides of March are here, war drums rumble,
and I'm thinking how, in another March, you came
with revolution, overthrow of elected might that had,
you thought, gazed too long on its own reflection.
With war wandering wild, I remember the ides of October,
how your grave became a seeping secret
spreading poison in the land,
how blood can poison plans imposing as mahogany,
how callaloo closed in on itself like shame bush,
when your blood soaked into the land.
With war's rotten stench in the air,
I remember you, in quieter, troubled times, standing,
watching the sea, one guard facing north, one south, one east,
one in front of you, blocking your view to the west.
I remember you imprisoned by your love.
I remember how you strained to watch the setting sun.

Day Two
War started these ides of March, with a selective strike.
War came to us, too, selectively, in your name,
not to avenge you, because for the warriors
it was good that you were gone, but to save your country,
so war said, from a murdering clan.
Did your energy, waking there, weaken when it dwelt on this?
Or did it, looking to a distant future, burn more brightly?
I think of you, body broken, crammed into a hole somewhere,
while planes patrolled and bombs blasted your office on the hill.
The blackened walls still stand, I suppose you know,
awaiting an elusive developer.

Day Three
In this the twentieth year, I wonder,
are those who have spent these years in prison,
there in your name?
Are they there because they killed you?
Held the gun, spoke the word, or signed the note?
Or because, top-ranking cooks of the liberating brew
you helped create, they all stood around the pot
and whispered, *bubble, bubble, toil and trouble*,
so had to share the blame?
In this the twentieth year, I write you because
I watch another people lift arms, put down arms, surrender;
wonder how many tried to defend an elusive thing
called love of country, from an alien, armed invader?
Were there those who mourned your loss,
who hated those who killed you, yet fought
the invaders after you were gone? I write you in this time
when war stirs ancient, recent, recurring memories,
wonder how many trade with the devil
just to escape the sharks of the chaotic deep?

Day Four
And you, unknown, you the ones
who fall and die, marching or looking on,
you the ones whose names remain hidden from the crowd,
you the ones mourned by mother, sister, brother, lover,
lamented by those who fear to speak,
who dread to call attention to a loss.
You the ones not celebrated by statues
or plaques, or memorial walls, or graves to the unknown soldier,
you who may have shouted love of leader,
who may have cried for love of country,
who may just have fought for love,
you who, killed in bed,

may not have known your part until you woke
to wonder in another light.
We give thanks for your journey here.

Day Five
In the beginning
was the Word,
and the Word each hears is the Word
of Olodumare, Jah, Allah, God,
Jehovah, Yahweh, Science, supreme.

A man stands over a crater hole
that was once a house,
looks down into the bottomless dark,
weeps and calls for his son, Mohammed.
And someone opens his arms and says,
Mohammed, there is no Mohammed.
Mohammed is not there.

And the prophets bow their heads and weep.
The Word that has been spoken before,
will have to be spoken again.

A Note

Twenty years ago, this reasoning was a howl,
was feet pounding potholes in panicked retreat,
was a broken scream at cross-fire words, flung,
sharp as shots, to spark candles to the sudden dead.

Twenty years ago, this reasoning was a numb horror,
a dumb gaping at a circling drone,
testing the rocky terrain of our humiliation.

Fifteen years ago, this reasoning was a groan,
was a blind groping back to beginnings,
was a journey back to whips and chains
and bodies trapped in a ship's putrid hold.

Fifteen years ago, this reasoning was a search through cane,
a march with unions,
a questioning of independence,
Black Power, parties, personalities,
was a swimming back to tread cautiously
through the loud, insistent, hopeful seventies.
Fifteen years ago, this reasoning was an excavation,
a digging through the tangled terrain of our humiliation.

Ten years ago, this reasoning was a questioning
was a sorting through images dug and bombed into the brain:
a storm of hands raised to punch away dissent,
a dying voice that spoke of splits and plots
and marching out to an uncivil, civil war,
a walk along the balance beam of party
and of personalities out of step
with parties they had declared supreme,
a drone, a helicopter, a crash of bombs,
a pig nudging at a friend's body in a stinking drain.

Ten years ago, this reasoning was a picking through
the crowded terrain of our collective treachery and humiliation.

These last five years, this reasoning has been
a return to beginnings,
a listening to the word spoken before
a walking over familiar bumpy ground
a parade of parties, personalities, preferences
has been the repetitive voice of the querulous nineties.

Today, this reasoning begins to move forward ever,
but wonders if there may be nothing new under the sun,
for in the sea of memory swims
a storm of hands raised to punch away opposition,
a force of voices chanting down dissent,
and, this reasoning notes, with trembling,
a group like silent Cassius,
with a lean and hungry look.

VOICES AND JOURNEYS

SOMEBODY WALKING OVER MY GRAVE

They could bring you messages
in the quiet hours of the night
but they know you are suspi-

cious of superstition, so
sometimes they wait for your day
dreams and lie down light across

them. That's when you shiver and
say, hmmm, I could feel somebo-
dy walking over my grave.

HOPING

Perhaps if I deliver
you my demon angels, you
could move back their folded wings

You might frisk them, touch them, find
the stories their bland angel
faces conceal. Perhaps if

I deliver you my de-
mon angels, you could put laugh-
ter in their heavenly faces

You might touch them, humanize
them, hold them, still the thunder-
ing that keeps them moving. Per-

haps if I deliver you
my demon darkness, you could
fold it, frame it, put it

where the light would touch it, ex-
plore it, make a frame of it,
place it where the light would al-

ways hold it.

HOME

Nothing but a name, and a sea-flash of blue
pulling me from my stranger's brooding
Berwick-upon-Tweed, a sudden blue reminding
that these are British *Isles*, and beautiful, too

A fleeting look that feeds some need
for sea, for mountain-dew laughter
for dust, for sky, for woods and water
for Caribbean Berwick-upon-Tweed.

To escape pursuing spirits, cross water
they say, for spirits cannot follow
but these have left the tang of mango
have crossed and mean to linger

From a train in England, on a journey home
a fleeting seascape, recalling dreams of home

LET S CROSS

You see me laughing here, is Tottenham have me laughing so
I watching my friend aiming at the West Green Road bakery
thinking bout the hard dough bread and fish paté
and I remembering another time, when she just back in London
from years in Brooklyn, years taking in New York, she tell us,
and those days she holding her handbag tight, tight, tight,
she clutching my arm to breaking as every black man walk up
and her voice rough with the whisper, *Let's cross, let's cross.*

You see me laughing here, is my black sister I watching so
I watching her these days, toe to toe and eyeball
to eyeball with this Tottenham brother,
I listening to her big and bold demanding
Why can't you look where you're going, then?
I hear her add, *git*, as he swings away and I say
Well, look at life. You see, I remembering dem long time days
when I hear her now, crossly shouting, *Let's cross, let's cross.*

You see me laughing here? Is times have me chuckling so.
I can't say I know what brothers in Brooklyn do my sister
but it please me no end to see how after her years back in London
I don't have to buy Iodex for my arm when she visit Tottenham
It please me to see how she keep a cross eye on her bag but she ain't
 frighten
how now she back talking to black man like she know him
It please me no end to see how she dodging traffic and
calling out calm and rough like yellow yam, *Let's cross, let's cross.*

It's as if this anxiety
likes absence, as if it feeds
on the soil of alien lands.

It's as if this anxiety
enjoys longing for the tongue
it cannot hear, feeds off

the strangeness of those it can.
Perhaps the love that this an-
xiety feels lives most comfort-

ably in alien lands. Some
seasons, green peas time, mango
season, this anxiety feeds

so much on absence that it
follows memory's taste
back to seed, to tree, to

root, to garden of Eden made
sweeter by the fall. From home,
voices wonder: You, too

thinking of this place as sea,
as sun, as carnival laugh-
ter, as rum and coconut

water? Long winters, so you
call for constant sun; icy
stares, so you crave famil-

iar spaces; long hours of work
to build some dream, so your mind
creates a restful space back

home. Well, come home to roam these
fields of laughter, come back to
blue surviving, come home to

peace, to river washing, come
to all that sunshiny fun.
But before you leave your roost

out there, help your cousin to
university, please. He's
out of work, lime gone sour.

His sister, she needs some books,
some socks for school. Here, the
little you send multiplies

by three, by four, by almost
five. So help – then come for blue,
for *bois canot*, for garden

of Eden, serpent free. This
anxiety visits, re-visits
till green peas sour the inside

again and this anxiety
thinks once more of distant lands
where love of home might feed deep

in restless, creative peace.

Sea, always returning, ev-
er travelling, whispering
instigator of a fur-

tive flight from mountain, from green
and shaded shelter. So why
this blue always calling? What

is love and why this wanting?
My mountain darkness taught a
deeper seeing: *bois canot*,

tall tree, protector; crouching
cocoa, needing shelter. I
see that life is light and life

is shadow. Mountain teaching,
shaping, but there is sea and
there is longing. Mountain breeds

mortelle, strong tree, decisive
boundary, but how feed this
hunger for tomorrow? Why

is sea blue distance with such
roaming wildness? I see how
mountain rain washes nutmeg,

leaves it rooted on familiar
soil, still growing, thriving on
mountain food. But sea winks at

me to make a wish. What is
love and why this wanting to
leave? Sea blusters in, moves me

to Venezuela, maps me
a federal farewell to

Jamaica, rocks me with Trin-
idad, St. Lucia, *dice*
adios and lets me loose

in Mexico. Star points north
but sea turns, shuffles, sighs, flows
and thunders, claims the voice of

mountain, calling. Come home, Gren-
ada, Concepcion, Cam-
erhogne. Find Mount Gozo, the

mountain, home. Sea, mountain,
both now distant, pull but will
not hold me. I shout Black Power,

I urge revolution and
make and name the nation.
Mountain counsels caution.

Bois canot, mortelle, nutmeg,
cocoa: some grow high and some
keep crouching. Some dress in red

and some are calmer. And
mountain murmurs, *Know the ar-
rogance of wandering. Seek*

the humility of home.
Sea rushes back to shore and
I watch, I wait, wondering.

I feel the revolution
rolling. I hear the guns and
sense the reeling. I hear

mountain, sea, both murmuring.
What is love and why this want-
ing? Mountain darkly warning,

grim, prophesying. Sea growl-
ing, impatient, thundering,
foaming. I no longer know

what is light and why is sha-
dow. I wander now to wrest-
le with my furies. I feed

my fears in winter flurries
I choke on the salt of strange
and distant seas. But still in

my head that sea, that thunder-
ing. Where is love and what is
wanting? Why the mountain still

in shadow? Why the sea, such
ominous rumbling? How feed
the hunger for tomorrow?

THREE TIMES SEVEN

So I walk three-stepping to
whispered seven. What ancient
rite rises to route my steps?

I swing seven backwards in
the face of confusion. Three
times I whisper a mantra.

Still, I don't know you by name
red that warns, compelling black.
From inherited habit

I swerve back to this verse and
three times I whisper seven
in the face of confusion.

ME ICO AUNQUE NO PARE CAMOS

She had become a friend and
talked about how
the *peso pesaba nada*

had no value, against the dollar
how *los inditos pobres en el tren*
no representan todos

how the poverty stricken Indians on the train
don't represent everybody
how *los niñitos esos de la calle*

no son como los niños míos
those street kids
are not like my children

how *esos malditos robadores*
nos dan todos mala nombre
those damn thieves give us all

a bad name, how they pay us
casi nada, and my Caribbean ears
are in tune with the familiar ring of

next to nothing.
And so, she says, we all look for
otra cosa, entiendes?

para poder alcanzar,
again the Caribbean search for
some little pankwai, you know,

just to make ends meet.
And by now I'm leaning forward.
I recognize this look, this

attitude of body, this
rap, this chat, those
arms that leave it up to

el padre Dios allá arriba
en el cielo, papá God
up there in the sky.

And then she sighs and says
te digo, mi amiga, no es fácil.
I tell you, my friend,

it's not easy.
Aquí en este país
trabajamos como negros

aunque no parezcamos.
Here in this country, she says,
we work like blacks

although we don't look like them.
I sit back.
I smile.

She leans forward.
She frowns.
And now there is nothing more

to be said.
When I leave I'm not thinking of
the *peso que pesaba nada*

or how *los indios esos en el tren*
no son como los niñitos míos,
nor how *esos malditos robadores*

nos dan todos mala nombre
No. I'm just wondering
whether *negros*

in that context
is translated
blacks or niggers.

A TOURIST IN ME ICO

Have you seen this yet?
Is this one *la pirámide del sol*?
Let's go see *la pirámide de la luna*

You're dying to wander along
La avenida de los muertos
You want to dedicate to the sun god

your sweaty tribute.
At the centre of your frenzy
is the crouched, caged stillness

of futility. You want to root again
beneath the haunt of names
Teotihuacán, Tenochtitlán, Taxco.

Next week you should go see the ruins at Tula.
You should buy a hammock in the Yucatán
You need to monitor the mixed magic

of modern Mérida.
Perhaps there you'll find
something more familiar

than Mexico City's coarse curiosity.
At the centre of your searching
is the stilled terror

of futility. You want to
submit again to the haunt of familiar faces
to challenge the stoic stare

of Olmecs, Toltecs,
to watch the pride of Aztecs.
But you drift to Vera Cruz

and it seems
not as familiar as you'd hoped.
You keep looking for someone

who would give you back your face
watching for Africa
like England abroad listens

for itself. At the centre
of your frenzy
is the caged stillness

of futility. You will want
to visit this Mexico
again, to submit again

to the curious haunt of
Tenochtitlán, Taxco, Tula,
Teotihuacán. At the centre

of all this frenzy
is the quiet terror
of futility.

HER SPIRIT KNEW

She'd always walked as if her spirit knew
there was something in a forgotten past
waiting to awake in an uncertain future.

Her eyes never really seemed to see.
Her head, tilted just slightly to the left,
lips, trembling always with a certain sadness.

All this I noticed still when we met again,
years after those early laughing days at school.
Her eyes, drawn more to space, couldn't focus on this world.

Her lips said she remembered, vaguely, she'd known me.
Yes, they said, yes, yes, but her spirit signalled no.
And even as I thought she should go home,

I knew this probably had been her home
more years than any other place.
And anyway, the eyes said that the spirit's no

wasn't just to the streets of Washington,
not just to cold, to sleet, to ice, to snow,
but no to memory, to hurt, to longing, to love,

no to sun, to blue, to sky, to sand,
no to sea, to green, to red, to land.

FALL

Fall flares outside my window
Green treetops change to orange
Yellow flames touch burning green

Black birds call and circle trees
The sky is Caribbean blue
Orange flame, yellow promise

changeling green: Maryland fall
recalls green of mountain trees
Blue sky brings blue sea; yellow

leaves, yellow poui blossoms
that float falling there while I, here
crouch caged in endless meetings

watch leaves fall, seasons changing
and I, twisting tongue around
syllables falling like life-

less leaves, brown bound back to ground
I wait, crouch caged here, while fall
strips trees and black birds call in song

MAN WATCH

Woman say
Me, I love mi callaloo soup

Man watch her
He see how she take she knife and stoop down in callaloo drain
How she search till she find some good callaloo
How she hold callaloo and cut it
How she wrap up callaloo and carry it inside

Man watch. He say, so is so woman does do when she love callaloo
He see how she hold callaloo and strip it
How she rest it down and she chop it up
How she put it in pot and she cover it down
How she turn up the fire under it
How she swizzle up callaloo to soften it

Man watch. He say, I tell you, I suppose she really love callaloo
He see how she change up callaloo with coconut
How she put meat and provision and whatever she fancy
How before she done she even add dumplin
How she cover down callaloo to keep it and turn down fire
How she sit back down and watch callaloo simmer

Man shiver, man say, woman well love callaloo
He see how she take callaloo and swallow it
How she wipe she mouth and smile satisfaction
How she take what's left and throw it in the garbage
How she turn she back and she gone

Man say, I could testify from experience
Woman love she callaloo in truth

WOMAN WATCH

Man say
One ting ah love
Is mi peas and mi dumplin

Woman watch him
She see how man pull peas off the tree
How he bend peas pod till he break it
How peas spill out it guts for him
How he cradle peas in the palm of his hand

Woman watch. She say, look how much man love peas
She see how man throw peas in pot and cover it down
How he give peas fire till it bubbling in real hot water
How he put in salt meat and coconut and whatever he fancy
How he stir the mixture with a smile of satisfaction

Woman shiver. Woman say, yes, man love he peas and he dumplin
Because she see how he take flour and roll dumplin long and tight
How he throw it in the pot and let fire harden it
How when peas cook man chew it and crush it
How he sit back down with a smile when he done
How he rub he belly and belch satisfaction

Woman say, I could testify from experience
Man love he peas and he dumplin in truth

SEA

Sea, when I look at you
I want to be
several shades of blue

I want to be the
translucent green of jade
I want to be

just your shiny silver shade
when I look at you, sea, I
want to be peace

Come wash me with that
cool, wet, whisper
I want to have a

blue sky lover
with horizon our
constant meeting place

I want to have a
sweetman sand
where I let those waters flow

Sea, after
rushing out to woosh and wander
I want to have that

sweet, sinky, wavy feeling on returning
I want to be peace so
come wash me with that

cool, wet whisper
I want to make a
soft, sinky, sighing sound with my

sandy silver lover
I want to have some
trees flaming shango on my shore

I want the
red flamboyant
setting off my blue

I want some
coconut palms sinking in my sand
I want to have

sky always there to cover me
I want to hold that
clear blue reflection in my face

Sea, come wash me with your
cool, wet whisper
I want to be peace

I want to be
just your shiny, silver shade

I want to be the
translucent green of jade
I want to be

several shades of blue, Sea,
every time I
look at you.

SOMETIMES IN THE MORNING

Sometimes in the morning,
before mouth noise chase away knowing,
sea murmur sweetness against rock,
whispering loud to interpret dreams.
One morning like that,
sea roll into my dreams like is sea know the meaning.
And sea murmuring,
Think how man flow here without clothes, without nothing,
think how woman swim in with not one stitch to she name.
Woman that come with nothing, going out without one thing.
Sea nibbling murmurs against rock,
then mouth erupt and you can't tell what was dream, what was wake.
Is shouting and slapping between rock and sea,
and it hard to remember the murmuring that happen
in the rock-whispering morning.

On a wall in Nicosia
the children have written,
Graves are lucky.
Dreams always lie in graves.
The wind, murmuring this dirge,
trails its echoes over other island seawaters.

On a wall in Grenada
someone has written,
Viva!
The wind, murmuring that defiant hope,
trails those defiant echoes, too, over island seawaters.

See all those closed, quiet windows of islands.
Some crave this blue peace for
restful dreams, for romance, for forgetting.
Viva! Dreams always lie.
Laughter curls itself over island seawater.

And the children, living in lands
divided by walls, choked silent by memories,
scribble that graves are lucky, that
dreams always lie in graves.
But they murmur, *Viva!*

So what will their children shout
when they come to recognize their dreams,
when they defy the luck of graves
to pull their dreams from the beds of mud again?

On a wall in Nicosia the children have written,
Graves are lucky.
Dreams always lie in graves.

From across the road a woman complains,
The little devils
keep scrawling across the walls.

My friend answers in Greek. He asks,
Did you see what they wrote?
They are mourning the death of dreams.

Tourists! She scoffs.
Always come to watch dirt on walls.
*Take it with you. Put the writing outside **your** house.*

My friend marvels, but the children have written,
Graves are lucky.
Dreams always lie in graves.

The woman marvels. *You are happy people.*
You come with your camera to take pictures
of dirt on walls.

In the beginning, a little house facing the road
sitting down in the crooked elbow of a hill
cousins, uncles, aunts, macomères slowing down to call out

How things going? Sa ki fèt? You holding on? Child, God is love.
We making it. God don't give more than you can handle
Papa God make he world uneven. Watch the fingers of you hand

Gadé. You see how all of them different length?
But never mind. The next generation to raise we nose.
You talk to Teacher yet? Oh, you buy reading book?

They know the ABC and their numbers already?
God don't sleeping. Put them in Teacher hand.
Teacher going shape them up. So macomère what not happening?

Ay ay! Come come come. Let me pinch you this thing.
You don't know what I hear down the road this selfsame morning?
Come, sit down for a minute let me tell you the story.

I won't take up too much of you time.
I know work, the master, waiting.
Child, go and pick up you reading book.

She could hear too much, you know.
Palé Patwa. Ou ba konnèt...? Eh!
When I hear I say, eh bien, wi!

Wéspé. Wéspé. Wait.
You reading you book, Madam?

In the beginning, a schoolhouse crouched
at the curve of one craggy hilltop
Teacher Lenorice, tall, tough, remote
and parents reaching for the commandments

Twice-times tables, the bumpy brown ground
Under the tree, chant of ABC
The long wooden bench, the shouted word
Royal Reader Book One, Book Two, Three

Chanted poetry, *The Rain Lesson*
Spider and the Fly, *The Beggar Man*
Wailing stories, *The Lost Child*
The Child's First Grief, *The Better Land*

Chattering with *The Parrot in Exile*
Eyes on *The Dog at his Master's Grave*
Story time with *Meddlesome Matty*
Poem story. Chant. *We are Seven*

Evening time come, word leave mountain top
Racing down from Teacher's nutmeg trees
At the curve of that stony hill side
In front was the valley. Beyond, the seas.

IT WILL BE TELEVISED

It seems the apocalypse
will be televised

I wonder if bush gram
will pick up the news

Tout moun ka pléwé
black is white

The apocalypse will
be televised

CHECKING OUT

My mother treats life like a hotel.
When time come for me to check out, she says.
My father, even before he saw death waiting at the corner,

seemed to find distasteful this my mother's
calm acceptance that they would both
check out, one day.

Still, when his time came before hers,
his manner of going reinforced my mother's notion
that death is just a walk out of this hotel

to a home on the other side.
He asked for a drink of water,
took it, stretched, was gone.

I always talk about checking out, my mother said
*but it's the first time I really see
it's just a case of checking out, in truth*

and then, just in case we might think
she had changed her mind,
she added, *Like I always say,*

*three score years and ten gone,
is bonus time I living now.
I thank the Lord for it,*

*but I ready when He ready.
I pack.
I ready to check out anytime.*

CUT THE DRUMS

Cut the drums.
Hold her, rock her.
Sing softly to her.
She got the power.
Soothe her.
Don't start the drums again.

Leave the drums.
Put down the iron.
Don't start again
With that shango shuffle.
Hum softly to her.
Don't start those drums again.

Don't touch those drums.
She's coming back.
She'll be all right.
Sing to her.
Soothe her.
Don't touch those drums for now.

ABOUT THE AUTHOR

Merle Collins was born in 1950 in Aruba but returned to her parents' Grenada a couple of months after her birth. Her primary education was in St Georges. She graduated in 1972 from the University of the West Indies in Mona, Jamaica, before going on to teach History and Spanish in Grenada and St Lucia. In 1980 she was awarded a Masters in Latin American Studies from Georgetown University.

Merle was deeply involved in the Grenadian revolution and served as a coordinator for Research on Latin America and the Caribbean for the Government of Grenada. She left Grenada in 1983.

Her first collection of poetry, *Because the Dawn Breaks*, was published by Karia Press in 1985. At this time Merle was a member of African Dawn, a performance group combining poetry, mime and African music. In 1987, she published her first novel, *Angel*, which follows the lives of both Angel and the Grenadian people as they struggle for independence. This was followed by a collection of short stories, *Rain Darling* (1990), and a second collection of poetry, *Rotten Pomerack* (1992). Her second novel, *The Colour of Forgetting*, was published in 1995.

Merle Collins is currently Professor of Comparative Literature and English at the University of Maryland.

Visit the Peepal Tree website and buy books online at:
www.peepaltreepress.com